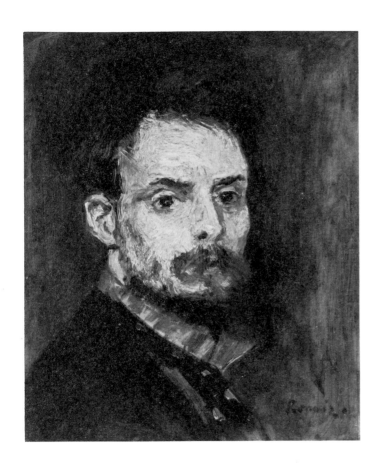

RENOIR
by David Thomas

THE MEDICI SOCIETY LTD
LONDON 1980

Bouquet of Spring Flowers. 1866. Fogg Art Museum, Harvard University (Bequest—Greville L. Winthrop). $41\frac{1}{2} \times 31\frac{1}{2}$ in (105.4 x 80 cm).

The flowers are those of spring as it turns to summer, and Renoir shows not only his delight in the random and transient splendour of the subject: he is drawing on traditions inherited both from European painting and the art of the porcelain decorator in which he was skilled. There is an equilibrium between these traditions and the fresh vivid eye of the young painter.

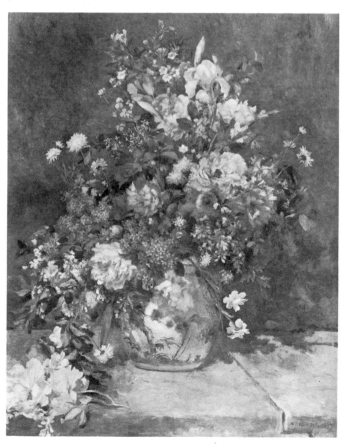

Pierre-Auguste Renoir, one of five sons of a tailor, was born at Limoges, a city in the centre of France famous for pottery and enamel work, on 25 February 1841. The family moved to Paris four years later, and at school Renoir must have shown an exceptional gift for music, for Gounod, who taught him singing, wanted him to study it professionally. Instead, at about the age of fifteen, he became an apprentice porcelain painter, and soon became skilled in this and other branches of decorative painting. For better or worse Renoir thus forfeited the continued intellectual training he might have received had his father been richer: on the other hand the unremitting discipline of this type of work provided a unique basis for draughtsmanship and facility with the brush. It is important also that in the world of decorative art the traditions of the French eighteenth century lived on, whereas in the schools of fine art they had died out. In the mature work of Renoir, like that of his contemporary Rodin, who underwent a similar training, there can be discerned not far below the surface the continuing influence of his absorption in this important layer of French artistic heritage. Becoming attracted to serious art, he took evening classes in drawing, and with money earned by painting walls and window-blinds, he was able in 1862 to enrol at the École des Beaux-Arts. Here his studio master was Charles-Gabriel Gleyre, and among his contemporaries were Monet, Sisley and Bazille, all of whom were to share in forming the new naturalistic movement which, during the 1870s, became known as Impressionism. While his new friends spent much energy in resisting the academic teaching of Gleyre, Renoir, though the fact that he thoroughly enjoyed working from the model caused displeasure, seems to have worked away quietly, taking advantage of whatever he thought valuable in the course. Also, soon

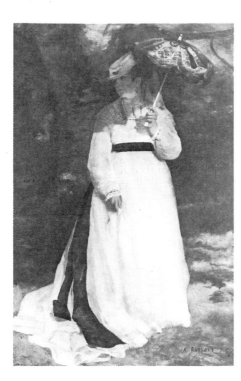

Lise. 1867. Folk-wang Museum, Essen. $71\frac{1}{2}$ x $44\frac{1}{2}$ in (181.6 x 113 cm).

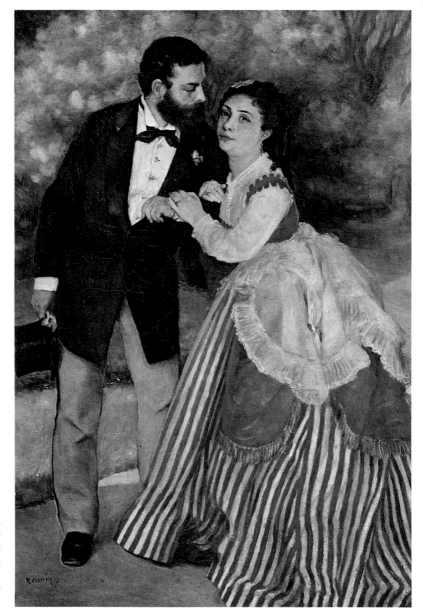

Sisley and his wife. 1868. Wallraf-Richartz-Museum, Cologne. $42\frac{1}{4}$ x 30 in (107.3 x 76.2 cm).

Alfred Sisley, French-born of English parentage, had been a student with Monet, Renoir and Bazille under Gleyre at the École des Beaux-Arts in the mid-1860s. In spite of the forthright realism of Renoir's approach at this time, the scene is not without tenderness. In this work, which belongs to the same group as *Lise* (this page), Renoir is already examining the presence of colour in shadowed areas.

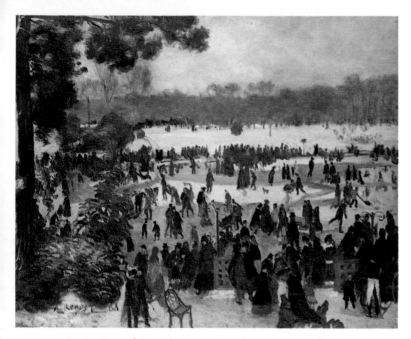

Les Patineurs à Longchamps. 1868. The Marquess of Northampton. $28\frac{3}{8}$ x $35\frac{1}{4}$ in (72.1 x 89.9 cm). Photo by courtesy of Sotheby Parke Bernet & Co.
Like water, snow and ice provide a medium especially attractive to a painter wishing to depict effects of light, and here, as in many later works by the Impressionist group, a city scene is made magic by the gleaming veil which envelopes the tiny animated groups of Parisians and their children.

requirements of harmony and construction in the picture. As the works of Fantin-Latour, who urged Renoir to look at the masters in the Louvre for himself, show, his conventions were not those of the École des Beaux-Arts (p. 4). He made close studies of the great Venetians, of Rembrandt, Hals and Vermeer, and also of Watteau and Chardin, and the portraits he painted of his contemporaries have a grave, composed look which reflects this deep study of earlier masters, his work being none the less clearly of its day.

In 1864, Renoir, with Sisley and Bazille, began to visit Chailly, a village on the edge of the forest of Fontainebleau. Monet, who was already working direct from nature, had been to Chailly the year before; but for Renoir and the others working in the open was a new experience. Moreover, as Chailly was in the

A studio in the Batignolles quarter by Henri Fantin-Latour. 1870. Musée du Louvre, Paris. $70\frac{7}{8}$ x $85\frac{3}{4}$ in (205 x 268.5 cm). (From left to right: Scholderer, Manet, Renoir, Astruc, Zola, Maître, Bazille, Monet.)

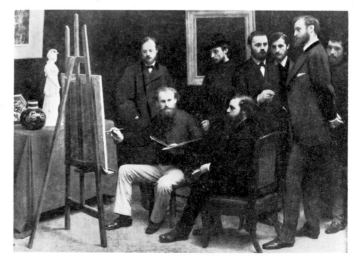

after joining Gleyre's, he had got to know Henri Fantin-Latour, five years his senior, who was to occupy a special position in the development of art in the 1860s. A friend of the cynical and unorthodox American painter Whistler, he was both anti-academic and yet reserved in his attitude to the radical and doctrinaire innovations, and knew that an art which found its raw material in the real life and people of the present would still have to be tempered by the

region of Barbizon, the group were to get from close proximity to the real founders of what is called the Barbizon School, Théodore Rousseau, Millet, Diaz, Daubigny and Corot, the kind of help they had not found at the École des Beaux-Arts. Renoir was noticed by Narcisse-Virgile Diaz, who, unlike the other Barbizon painters, used a multitude of rich, piled-up brush strokes and, still less typically, a vivid palette. The friendship of the older man was important to Renoir in several ways.

Renoir already admired Corot and more particularly Courbet, and many works of this period, in their qualities of mass and sensuousness, show the influence of this giant of realism (see *Lise*, p. 3.). Nevertheless, the palette of Renoir, which grew more delicate towards the end of the 1860s, may owe something to Diaz, himself a former porcelain painter, and the young artist's long experience in this trade, where white surfaces were often employed, should be taken into account.

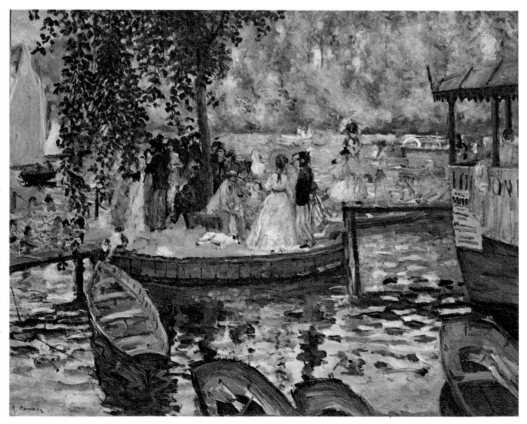

La Grenouillère. 1869. National Museum, Stockholm. 26 x 31⅞ in (66 x 81 cm).
The group of paintings of this bathing resort near Chatou on the Seine where Renoir worked with his friend Monet introduces many of the characteristics of what was to become known as the Impressionist style. The broad, firmly contoured forms seen in works like *Lise* no longer appear: instead surfaces are broken and divided, ripples on water being especially apt for the analysis of light and the colours of which it is made up. Apart from his purely visual concern, Renoir's choice of this lively scene shows how he loved to record everyday pleasure and relaxation, as Degas did the concentration necessary for everyday work.

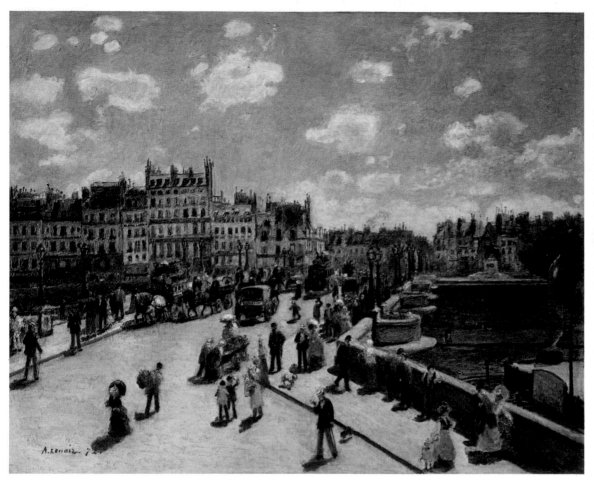

In 1864 one of Renoir's works, a portrait, was accepted for the first time at the Paris Salon, though, after the exhibition, he destroyed it as his work at Barbizon had changed his aims. He showed two pictures the following year, but, in 1866, with Bazille, Cézanne and Manet, his work was rejected. He continued to work in the forest of Fontainebleau, at Chailly and later at Marlotte, and in his work of about 1867 he comes closest to the raw and weighty realism of Courbet (an external pointer being his free use of the palette knife). When he employed this style in a large mythological canvas, the *Diana* of 1867 (National Gallery of Art, Washington), it was excluded from the Salon of that year, no surpise when we remember the anecdotic and trivial treatment of classical subjects then in favour. Lack of official recognition compelled

Renoir and his friend Monet to work in the severest poverty, since there was at that time no other way open to an artist to make his work known to the public. Their friend Bazille, whose parents were rich, was able to help them from time to time to avoid actual starvation and it is astonishing that in the work of the two artists this poverty is never felt. Renoir's serenity in the face of hardship is perhaps explained by the maxims he used in the conduct of his life. His son Jean tells us that he preferred instinct to reason and claimed

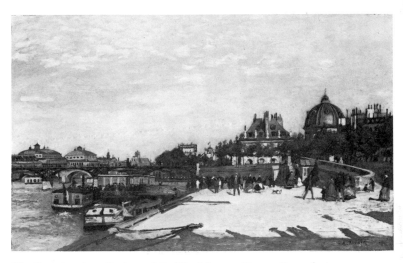

The Pont des Arts, Paris. c.1868. The Norton Simon Foundation, Los Angeles. $24\frac{1}{2}$ x $40\frac{1}{2}$ in (62.2 x 102.9 cm).

Monet painting in his garden at Argenteuil. 1873. Wadsworth Atheneum, Hartford, Connecticut (Bequest of Anne Parrish Titzell.) $19\frac{5}{8}$ x 24 in (50 x 61 cm).
Both this canvas and the one Monet is seen painting are works of high Impressionism. They show the interpenetration of light and colour which, even more than the palpable forms of the houses and gardens, is the real subject-matter. On the visits which Renoir made to Monet at this time he made several studies of his friend and his wife Camille, as well as the river motifs which both artists enjoyed.

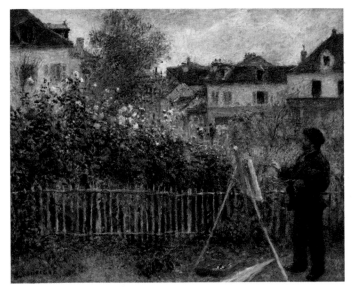

to have acted rather 'as a cork in a stream' than to have deliberately shaped his career. He worked very hard, but only at what gave pleasure and seemed natural to him. Self-educated or not, he was keenly aware of what was false in the alternative doctrines of religion and politics: moreover he disliked newspapers and advertisements since their production involved the destruction of forests. He took an intense delight in natural beauty and thought ugliness in architecture and design a more serious danger even than war, believing it to be a cause of violence.

The Pont des Arts (p. 7) meanwhile shows the full reach of Renoir's first mature landscape style. Though the overall tone is high in key, the organisation and handling are still broad and simplified. It is helpful to compare this work with that of Renoir's predecessors Corot and Manet, as well as paintings of this date by his

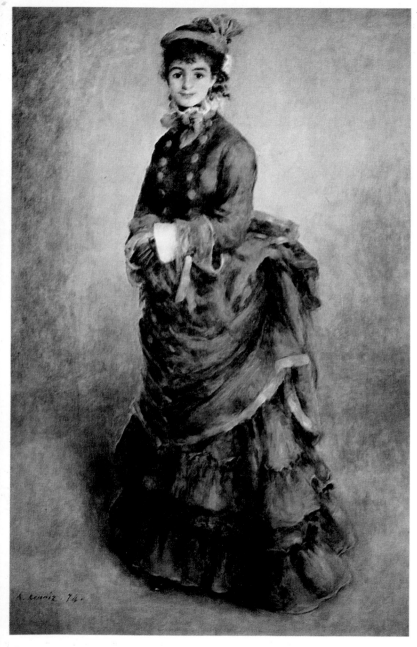

La Parisienne. 1874. National Museum of Wales, Cardiff. 63 x 41½ in (160 x 105.4 cm).

A comparison with *Lise* (p. 3) painted seven years earlier shows the completeness of the change of manner adopted by Renoir. The paint is thinly worked and scumbled into translucency, only the head being firmly established and sharply focussed. The physical setting is merely atmospheric, grey and misty. The sitter was the actress Henriette Henriot, a favourite model of Renoir's.

friends Bazille and Monet. As regards portraiture, in the last years of the 1860s there is some modification of the Courbet-like bulk of Renoir's preceding works, and in the *Sisley and his Wife*, 1868 (p. 3), with its softened execution, the broad simplicity of his early style begins to change. There was a relaxation of the intolerant attitude of the jury at the Salon of that year, and the important portrait of *Lise* (p. 3), in which sun and shadow are the controlling elements, was admitted. This relaxation was largely the result of energetic pleading by Daubigny, one of the leaders of the Barbizon school, as a result of which not only Renoir, but Degas, Monet, Sisley and Berthe Morisot were able to exhibit. There were efforts by their enemies to get the pictures hung as badly as possible, but, in spite of this, the group were able to score a measure of success.

About this time it became their custom to meet on most evenings at the Café Guerbois in the then pleasant quarter known as Batignolles, Manet being at the centre of most discussions. Several of the Batignolles group appear in Fantin-Latour's portrait painted in 1870 (p. 4), before they were separated by the Prussian invasion. One of their main topics was the art of Japan, which, since the opening of that country to trade in the 1850s, had become admired by modern French artists. Its incisive realism of subject-matter and its rejection of

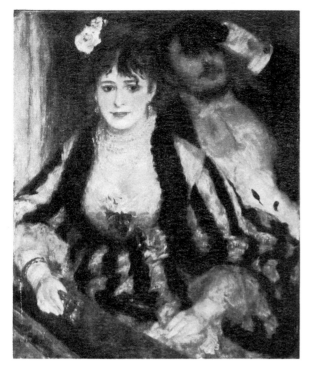

La Loge. 1874. Courtauld Institute Galleries. $31\frac{1}{2} \times 25\frac{1}{4}$ in (80 x 64 cm).

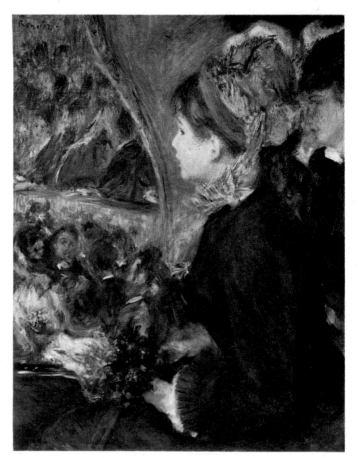

'*La première sortie*'. c. 1876–7. National Gallery, London. $25\frac{5}{8} \times 19\frac{1}{2}$ in (65.1 x 49.5 cm).
Renoir here uses the method of high Impressionism not to present outdoor nature under sunlight, but the dazzle of gaslight, costume and *coiffure*. Nevertheless, the telling of a story predominates and the experience of girlhood confronting the sophisticated world is set down with great tenderness and sympathy.

the perspective conventions of Western academies was particularly exciting to them. Another form of exoticism which particularly excited Renoir was to be found in the oriental subjects of Delacroix. This brilliant and somewhat withdrawn figure, born before the turn of the century, was still at the head of the school of painting called 'romantic', a word of many interpretations but for younger painters summarising all that was opposed to the formal neo-hellenic, linear style of the academies. In the work of Delacroix, as we can see for ourselves, the great colourist tradition of

Venice and of Rubens was passed on to the lively new schools of the later nineteenth century. These schools also found encouragement in his spontaneous use of paint, his disdain for cold and contrived composition, and his love of passionate and exotic subject-matter. Not all these things were to retain Renoir's life-long interest, but in another respect Delacroix was held in lasting regard, since it was he who had begun a scrutiny of colour phenomena which was to inspire, and be taken further by, first Renoir, Monet and Cézanne and later van Gogh and Seurat. These phenomena were probably an important subject of discussion at the Café, and here, perhaps, the colour aims which the group attained in the 1870s were formulated; notably the modification of local colour by reflected colour (e.g. from foliage or the walls of buildings); the modification of shadows for similar reasons, and the need for a general heightening of tones which this truer analysis of shadow would bring about. Two further kinds of phenomena, the mutual intensification of complementary colours when used side by side, and the illusion by which we perceive, at the edge of an area

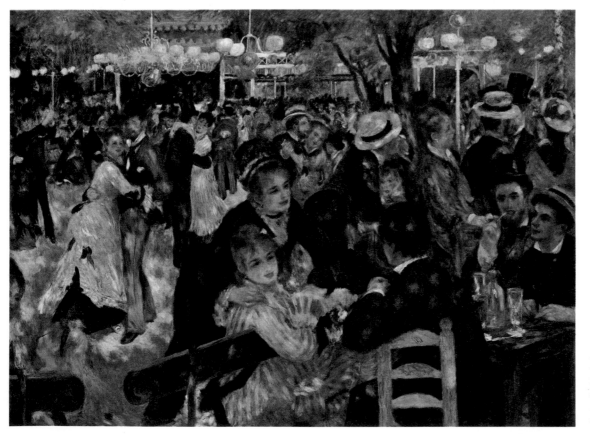

Le Moulin de la Galette. 1876. Musée du Louvre, Paris. $51\frac{1}{2}$ x 69 in (130.8 x 175.3 cm). The 'Bal du Moulin de la Galette', consisting of a pavilion and garden, was sited on the Butte Montmartre. It was a favourite resort of artists, students, artisans and their partners, and many of Renoir's friends appear in the painting.

of intense colour, the colour complementary to it, were to become topics of special interest among artists both of Renoir's circle and their successors in the 1880s. Renoir worked with Claude Monet in the search for a means of expressing these things in oil paint on a canvas surface, and their excitement as the search progressed can be felt in the work they did together at the bathing place on the Seine called *La Grenouillère* in 1869

Renoir now moved away from the massive, plain style of the large figure paintings of the 1860s in which Courbet's influence predominates, and he began to draw out his paint into feathery strands, breaking

Nude in the sunlight. 1876. Musée du Louvre, Paris. $31\frac{1}{2} \times 25\frac{1}{4}$ in (80 x 64.1 cm). Exhibited at the second Impressionist exhibition, 1876.

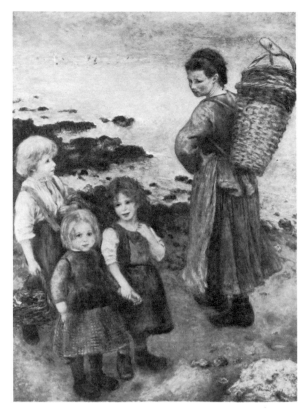

Women gathering mussels at Berneval. 1879. The Barnes Foundation, Merion, Pennsylvania. $70 \times 51\frac{1}{4}$ in (177.8 x 130.2 cm). Photo © 1980 The Barnes Foundation.

down large masses and their local colour into richly varied component forms which at a distance merge to give the illusion of local colour, but are now modified by fleeting effects of colour and light.

At this critical point in the emergence of something quite new in European art, the disastrous war between France and Prussia broke out. It lasted from 18 July 1870 to 28 January 1871, and was followed in the spring

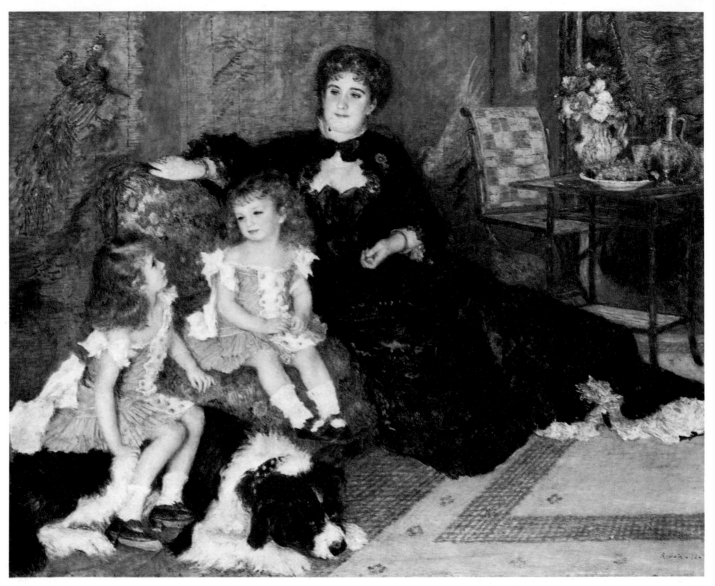

Madame Charpentier and her Children. 1878. Metropolitan Museum of Art, New York. $60\frac{1}{2}$ x $74\frac{7}{8}$ in (153.7 x 190.2 cm). Prominent at the Salon of 1879 was this successful and somewhat showy portrait of the wife and children of Renoir's influential patron, the publisher Charpentier, whose support marked a turning-point towards Renoir's social and financial advancement after the 1870s.

of that year by the greater tragedy of the civil war of the *Commune* in Paris itself. The Batignolles group were scattered, some of the artists joining up and others taking refuge. Monet went to England, Bazille was soon killed at the front, and Renoir, called up with the *cuirassiers*, was lucky enough to spend the war near the Spanish frontier. He was in Paris during the horrors of the *Commune*, but his ecstatically sensuous vision of the world about him seems to have been no more affected by this than by poverty, and when peace returned he was finding a large part of his subject-matter in the city and among its inhabitants, painting portraits and street scenes. Quite often he joined Monet on the Seine just outside Paris at Argenteuil, and they again worked at the same subjects (see p. 7). Here Manet sometimes joined them, but while now convinced of the value of Monet's open-air researches, the respected elder painter, himself still regarded as a dangerous radical, could see no merit in Renoir's work and sought to discourage him. Renoir's treatment of form in the first half of the 1870s reached its most evanescent, and his brush strokes their greatest delicacy. His famous

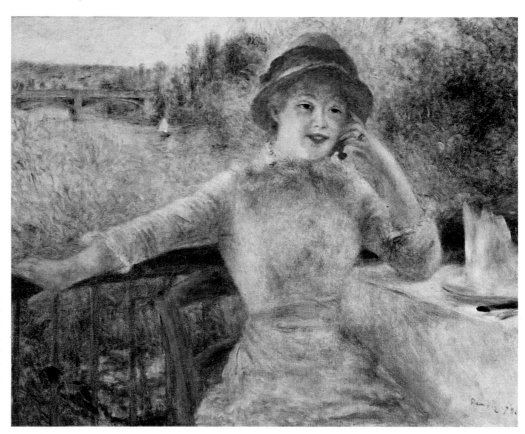

At the Grenouillère. 1879. Musée du Louvre, Paris. 28 x 36¼ in (71 x 92 cm).
The sitter is probably Alphonsine Fournaise, daughter of the proprietors of the *guinguette* known as *La Grenouillère* near Chatou on the Seine to the south-west of Paris (see also p. 5). Her rigid pose contrasts rather strangely with the transient effects of blue shadow on her white dress. The summer landscape behind is steeped in yellow-green tints.

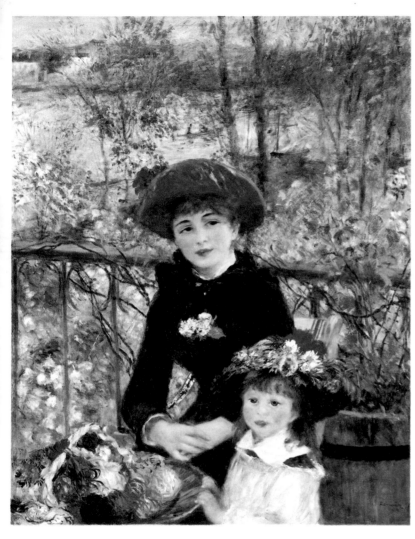

On the Terrace. 1881. Collection of the Art Institute of Chicago. $39\frac{1}{2} \times 31\frac{7}{8}$ in (100.3 x 81 cm).
Painted on the balcony of the Restaurant Fournaise, Ile de Chatou. This very popular portrait shows the characteristics of Impressionism, as developed by Renoir, at their most advanced. Among these is a marked artificiality of design, and in the drawing of the figures and their placing Renoir has sacrificed natural space and volume for a playing-card-like frontal disposition, also imposing a softening focus on the background material as it recedes.

picture *La Loge* (p. 9) was one of his seven works shown at the first exhibition of the *Société Anonyme des artistes, peintres, sculpteurs, graveurs, etc.*, held at the studio of the photographer Nadar at 35, Boulevard des Capucines from 15 April to 15 May 1874, and now remembered as the first exhibition of the movement led by Degas, Pissarro, Cézanne, Monet, Renoir, Sisley and Berthe Morisot. It fell to Renoir to organise the hanging of the widely differing works; there were thirty participants in all, and the rather vague label *Impressionist* coined at the time of this exhibition has stuck to them ever since. In fact, all the artists have widely different personalities, and it was for hardly a dozen years between the late 1860s and the end of the 1870s that their aims and works really coalesced. But since they aimed at such intangible fleeting qualities of light and colour, it is surprising to find the movement so united even for a decade. Perhaps this is explained by another factor they held in common — their choice of scenes from the city and its environs, with real, usually middle-class people at work, eating, drinking, bathing, boating, dancing, or playing instruments. Renoir took an obvious delight in painting pretty girls and their usually attractive mothers, and after the middle 1870s began to enter the exciting social circle led by Zola's publisher Charpentier and his wife, who with their family appear in many portraits. The

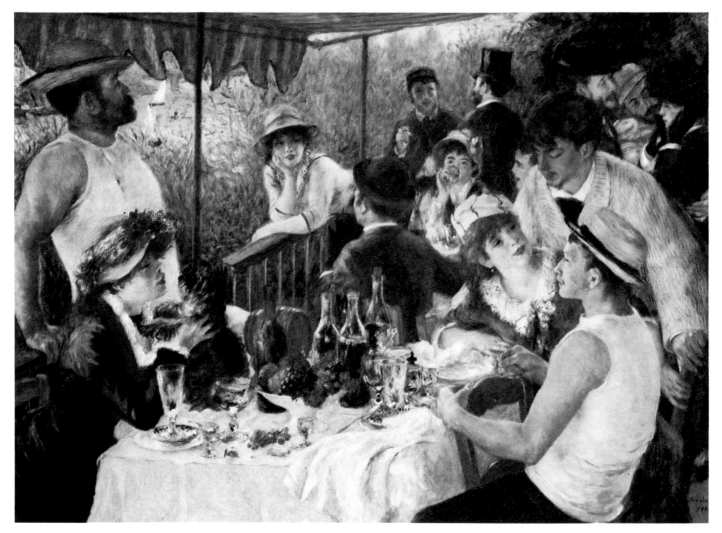

Le déjeuner des canotiers, Bougival (the oarsmen's lunch party).
1881. The Phillips Collection, Washington, D.C. 51 x 68 in
(129.5 x 172.7 cm).
Renoir uses a canvas of the size once reserved for the gods and
heroes of mythology to depict again the pleasures of life, and
especially those of the senses. On the left, holding a dog, is his
future wife Aline Charigot, and the boating party includes several
other friends.

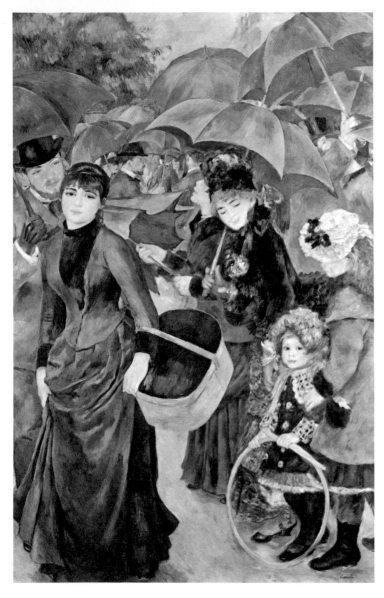

Les Parapluies. Begun before Renoir's Italian journey of 1881–2 and finished subsequently. National Gallery, London. & National Gallery of Ireland, Dublin. 71 x 45¼ in (180.3 x 114.9 cm).

This vivid presentation on a large canvas of surprise and bustle at the onset of a summer shower shows a transition from Renoir's Impressionist style to the quite different one which succeeded it. The woman and two children in the right foreground retain the soft and ornamented handling of the 1870s while the background and the girl on the left show the broad and simplified formal treatment to which the artist resorted when he decided that Impressionism could be taken no further.

Impressionists, in spite of journalistic attacks, gained ground through their joint exhibitions, of which, up to 1886, a further seven were held. Their defiance of the Salon in the 1870s was made easier by the support now given them by the important dealer Durand-Ruel. His help in terms of finance and moral encouragement was of such an exceptional kind that it is fair to say that had it not been given and maintained over several difficult years the Impressionist group could not have produced the work by which we now identify it. Two other patrons began to acquire Renoir's works from time to time. These were Gustave Caillebotte, an engineer and amateur painter of wealth and unusual sensitivity, and Victor Chocquet (inside back cover), a civil servant who, already an enthusiastic collector of Delacroix, became a close friend of Cézanne as well as of Renoir. It was at this time too that Renoir's famous portraits of women and children began to earn him a public reputation, perhaps at first due to no more than their irresistible charm. He was now able to take a house in the rue Cortot, Montmartre, and here he painted the famous *Balançoire* (Louvre, 1876) and the *Moulin de la Galette* (p. 10), in which several of his friends mix with the dancers. Obvious as are the attractions of these works, the public and the press were still unable to take

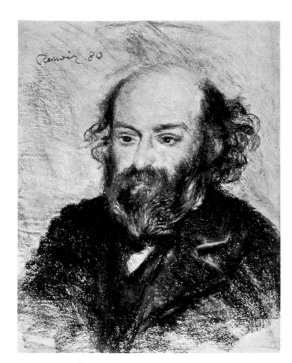

Portrait of Cézanne. 1880. British Railways Pension Fund. Pastel, $21\frac{3}{4}$ x $17\frac{1}{4}$ in (55.2 x 43.8 cm).

end of the 1870s, like several of his colleagues, he began to feel that the observation and recording of the visible world under direct and reflected light and colour could be taken no further, and that Impressionism, the art of seizing the fleeting moment, had reached saturation point. Renoir, in following this course for a bare dozen years, perhaps now looked back to his formative days

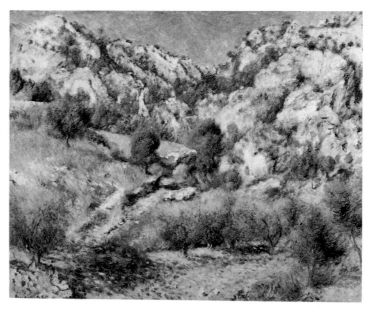

Crags at l'Estaque. 1882. Museum of Fine Arts, Boston (Juliana Cheney Edwards Collection). 26 x $31\frac{3}{4}$ in (66 x 80.6 cm).
Painted while Renoir, after his visit to Algiers, Sicily, Rome and Naples, was staying with Cézanne early in 1882. Turning from the fleeting light effects of high Impressionism he now sought the unvarying features and more constant sunlight of the rocky southern landscape as an aid to achieving the 'simplicity and grandeur of the ancient painters'. Cézanne was already deeply involved in his struggle to combine these qualities with Impressionist principles of colour, and Renoir, now working as Cézanne's disciple, was to confront and find his own solution to the problem. During this visit Renoir contracted pneumonia and was nursed by Cézanne and his mother.

seriously even the third Impressionist show, held in 1877. Many of the jibes about modern art which have gone on being repeated for nearly a century as new forms of art have appeared were first used of this exhibition, though the total value of the works shown would now be impossible to calculate.

Renoir however had not long to wait before making a really decisive success at the Salon. This came in 1879 when his group of *Madame Charpentier and her Children* (p. 12) was shown. Renoir could undoubtedly have continued to paint in this high Impressionist manner for the rest of his life; but at the

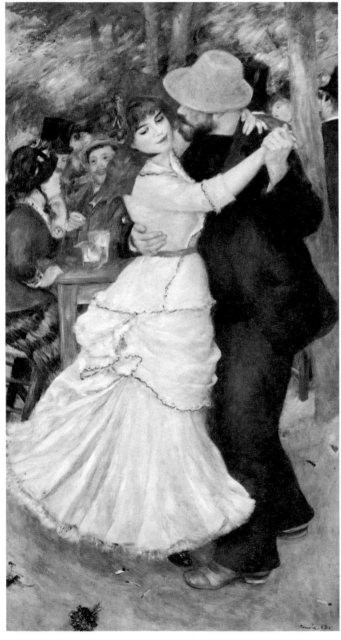

Dancing at Bougival. 1883. Museum of Fine Arts, Boston (Picture Fund). 70 x 38 in (177.8 x 96.5 cm).
One of three large paintings of dancers in which the artist Suzanne Valadon, then a young model, appears. Renoir at this time was striving to return to ordered composition and a clear definition of form, both of which he now believed he had too often sacrificed for the sake of effects of light.

in the 1860s when his naturalism had been controlled by massive design, breadth and much more firmness of contour. *Women Gathering Mussels* (p. 11) may indicate a reaction in subject and handling against the saturated charm of *Madame Charpentier and her Children*. It was Degas, who had never wholly departed from the astringent conventions of French classical painting, who now seemed both reactionary and forward-looking, and whose scepticism about the composition of the fourth group exhibition, held at No. 28, Avenue de l'Opéra in 1879, began a decisive split in the Impressionist movement.

1881 was the year of Renoir's marriage to Aline Charigot, and in this year he began a series of journeys, mainly to the classical world of the Mediterranean. He went first to Algiers, where, as Delacroix had said, the living forms of the ancient world could still be encountered. He visited Rome, studying Raphael's Vatican frescoes, and also Naples where the wall-paintings of Pompeii made a deep impression. Such works, whose classical discipline exists side by side with great vitality and sensuousness, helped to point a way out of the dilemma of Impressionism. Renoir had also stayed in Venice and had studied the work of Veronese, whose work shares these characteristics. He was now also ready to look again at Ingres, whose portraits and superb drawings of women also combine the maximum of both discipline and sensuous feeling. Finally, on his way home he stayed at L'Estaque with

Cézanne, who had long before embarked on his struggle to temper the impressions of the senses with the austere discipline of 'the art of the museums'. The group of paintings done by Renoir with Cézanne show that, though over forty and with brilliant successes behind him, he could accept the role of pupil to the still unknown colossus of Aix (see *Portrait of Cézanne* and *Crags at L'Estaque*, both on p. 17.) He now abandoned his concern with passing phenomena of light and shade, and, following Cézanne's example, sought out the permanent bone structure underlying the surface landscape. The searching and relatively

Les Grandes Baigneuses. 1884–7. Philadelphia Museum of Art (Mr and Mrs Carroll S. Tyson Collection). $45\frac{1}{2}$ x 67 in (115.6 x 170.2 cm).

In this picture Renoir looks beyond the 18th-century rococo tradition of his craft apprenticeship to the clear and lucid French style developed in the 16th and 17th centuries and especially connected with the decoration of architecture. It is interesting that his looking-back led to a simplification of form which we call Post-Impressionist and regard as a stage towards the development of the movements of the early 20th century. Renoir's Impressionist colleague Camille Pissarro thought the composition lacked unity, but the Post-Impressionist van Gogh admired its 'pure clean line'.

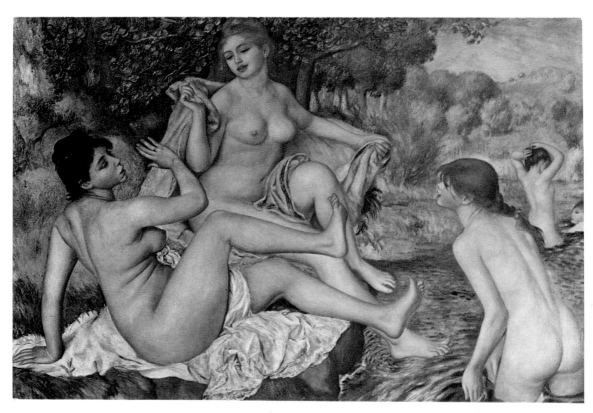

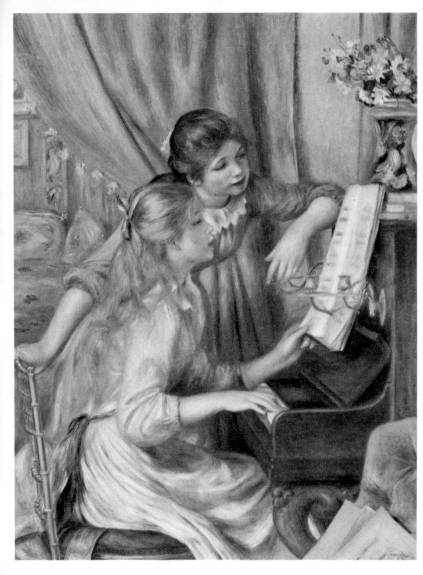

Jeunes filles au piano. 1892. Musée du Louvre, Paris. 45½ x 34½ in (115.6 x 87.6 cm).
This picture, the first by Renoir to be purchased by the State, was acquired in May 1892. Renoir himself nearly became a student of music and shares his love of musical subjects with painters of the Flemish, Dutch and Venetian schools. The player's hand turning the sheet of music draws our attention to passing moment which here as elsewhere Renoir seeks to fix.

unchanging sunlight of the south now replaced the vapour-laden, delicate and intermittent daylight of northern France which had been the chief medium of Impressionist vision. It was in this year that Renoir exhibited with the Impressionists for the last time. His large figure compositions now also begin to show more simplicity and grandeur of scale, with more sharply defined contours. The flowing, drifting complexity of brushwork seen in the 1870s gives way to a flatter treatment, and this break in style can actually be observed in *Les Parapluies* (p. 16). *Dancing at Bougival*, 1883 (p. 18) also belongs to this period of rigorous self-criticism and clarification. The change in style became evident in 1883 when Renoir held a one-man show at Durand-Ruel's; at the end of the year he again visited Cézanne, as he did again in 1885. Following the birth of his son Pierre in that year he began to paint magnificent family portraits and groups (p. 21). His second son, Jean (see pp. 22–3), who became the distinguished film director, was born in 1893. There is some relaxation in the later 1880s of the astringency of Renoir's classically disciplined new style, and we begin to find the grandeur and amplitude of his figures tempered by a loosening of the brushwork. In his colour, instead of contrasts of hot and cold or of pairs of complementaries, we find new harmonies built from a complexity of related tints, for instance red ochres, vermilions and umber, burnt and

raw, intensified with sparing touches of crimson until a glowing sonority is achieved. 'I have no rules and no methods', he is reported to have said in 1908*. The mass and simplicity of the figures take on more and more importance in these works of his later years (see *The Shoelace*, p. 24).

An important landmark in the history of Impressionist painting came when Caillebotte, who died in 1893, left his rich collection of paintings by

The painter's family. 1896. The Barnes Foundation, Merion, Pennsylvania. $68\frac{1}{8}$ x $55\frac{1}{8}$ in (173 x 140 cm). Photo © 1980 The Barnes Foundation.

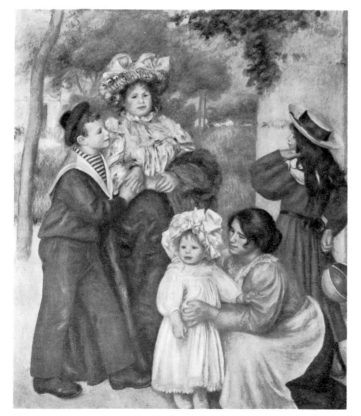

Le chapeau épinglé (the pinned hat). 1898. Art Gallery, Aberdeen. Colour lithograph. $24\frac{1}{4}$ x 20 in (61.6 x 50.8 cm).
Renoir is said to have preferred lithography to other reproductive processes because of the spontaneity and directness which drawing on the stone permitted. There is a striking contrast between the delicacy of the subject and the bold simplicity with which the forms are represented.

Portrait of Jean Renoir. 1899. Abels Gemälde-Galerie, Cologne. $16\frac{1}{8}$ x $12\frac{3}{4}$ in (41 x 32.4 cm).

Renoir's portrayal of his second son at the age of five contrasts interestingly with the later one reproduced opposite, in which the total absorption of the child in his task is dominant. Here the boy shows an attitude of receptiveness and wonder at the crowded impressions of a child's world. Renoir's paint is fluid and so traditionally handled that we are reminded of Fragonard or Gainsborough.

Manet, Pissarro, Monet, Renoir, Cézanne and Degas to the State. In spite of violent protests by all kinds of public figures, a large proportion of these works were accepted by the Luxembourg Museum after a long period of embarrassed consultation among officials. This museum, situated in the former Orangery of the Palais du Luxembourg, then contained a State collection of works by contemporary artists. By 1897 six works by Renoir, including *La Balançoire* and the *Moulin de la Galette*, had at last entered the national collections, and in the meantime buyers in the U.S.A., prompted by Durand-Ruel, were establishing the vogue for Impessionist paintings which Europe was later to follow. Renoir had long been well-known in Paris society, and while not forgetting his numerous friends and models of former days, had come to be on intimate terms with many personalities famous in politics, medicine, business and the theatre. Apart from Durand-Ruel his work was sought after by many notable dealers, including Vollard who later wrote reminiscences of the artist, the Bernheims, and Cassirer of Berlin.

Renoir's health had been unsatisfactory after the end of the 1880s, and after 1902 rheumatism had begun to cripple him. This did not lessen his pleasure in painting, and he began to pass the winters at Cagnes, between Nice and Antibes, working in his house and

Jean Renoir drawing. 1901. From the Collection of Mr and Mrs Paul Mellon. 19 x 22½ in (48.3 x 57.2 cm). The bunching of head, hands and shoulders in a strongly contoured single motif strengthens the sense of absorbed concentration in this unique portrait of Renoir's second son, later the great film director and author of *Renoir my Father*, then aged seven. The cool greys and fawns, with the extreme simplicity of conception recall the painting of Spain, especially that of Velasquez.

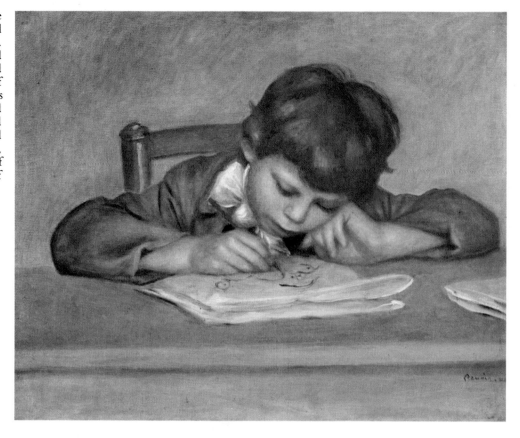

garden at Essoyes during the summer. In 1901 his third son Claude was born and he was also appointed Chevalier of the *Légion d'Honneur*. In 1904 a large section of the Salon d'Automne was given over to his works, and a seal thus set on his reputation at home, just thirty years after the first exhibition of the Impressionist group. To a discerning observer, looking back at this event, it must have seemed sad that journalists, critics and the public had denied themselves for so long the pleasure to be had so easily from the works of these painters, who had struggled bitterly to bring them into being.

By 1908 Renoir could walk only with the aid of two sticks, and from 1912 had to work in a wheel chair with his brushes strapped to his wrists. Yet in 1913, encouraged by the dealer Ambroise Vollard (inside back cover), he began again to work as a sculptor, having already done some small works in 1907 and 1908. Unable to use his hands to execute the work, he employed a gifted young modeller, Richard Guino, to

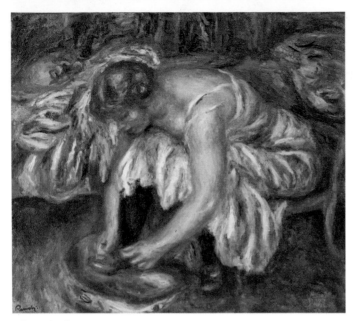

The Shoelace. 1918. Courtauld Institute Galleries, London. $19\frac{7}{8}$ x $22\frac{1}{4}$ in (50.5 x 56.5 cm).
This picture, painted towards the end of Renoir's life, has an air of concentration similar to that of *Jean Renoir drawing* (p. 23) and uses similar formal means – the figure doubled up with head, feet and hands all closely knit as in the child portrait. It was painted when Renoir, as he stated, had abandoned all rule and method, applying paint, in spite of stiffened fingers, touch upon touch to obtain the fullest possible richness of closely modulated colour.

work for him. This man's extraordinary insight into Renoir's aims enabled him to prepare clay and plaster models from Renoir's drawings, and the artist would then indicate with a pointer where he required modifications to be made. In this way even large works like the bronze *Vénus Victorieuse* and *Washerwoman* were produced ready for casting in bronze. The sculptures, made in the closing years of Renoir's life, establish in three-dimensional form the increasing

simplification and plasticity he had been applying to figure paintings since the later 1880s (see *Mother and Child*, bronze, p. 24). In both media he had travelled far beyond the kind of optical survey which was the basis of Impressionist painting. These works show perfectly the transformation of nature which the finest artists have achieved in their latest years, by means of wilful and quite unconcealed modifications, suppression and what is sometimes called, in a hostile sense, 'distortion', to describe what is often a necessary means towards the harmony which the artist seeks to create.

Renoir, who was able to work to the last, and who outlived all his comrades except Monet, died at Cagnes on 3 December 1919.

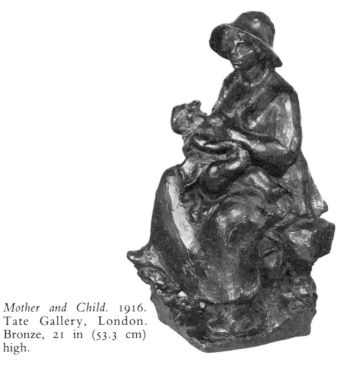

Mother and Child. 1916. Tate Gallery, London. Bronze, 21 in (53.3 cm) high.